Letting Creativity Flow

I see so much of the confusion with people. So much differences in thoughts all trying to come to the same understanding. When the understanding is right there always.

The wind blows softly at night. It's not good enough. The sun sets on the ocean. It's not good enough. The morning dew crystallizes the ground. Birds dance gracefully in the morning sky. Smells of hey harvested, and a apple pie in the oven. Still not good enough. Wanting proof of beauty in others. Yet, they don't see it for themselves. They enjoy it the next year before it happens all over again. They remember it from the year before, but never when it is happening.

I share what i see, what I feel, and it is only passed on threw my words because I take the time to see it. I didn't just read the saying, I took it to heart. I run through the fields with my hands out touching the

crop. I feel the pointed wheat brush against my hands like the artists brush of the ground. I feel the tears coming down my face as I have this time with humans. My only disappointment. It leads me to God.

No wonder wars happen. No wonder divorce is so excepted. No one runs threw the wheat fields and feels the brush strokes painting the feeling of life on their hands. They only read about it and say it's good enough.

I have a clover in my hand. It's just a clover, but so many will make it a wish. But the fact that it's in my hand is the wish. I will shut up now.... This is nothing new. I will cut myself off from those who can't seem to collect the evidence themselves. The fight... It's insane.

When living in the mountains their is no mockery. No intent to upset what it is you desire. No heaven with rules. No love with a book dictating the idea of it. It just IS! And the words in that world have no point.

FEEL... IT. Be it...... talk is like gas. It is here, it can light a fire.. and that's all it is.

I feel.... And I know what that means. Lost in the trees I swing from tree top to tree top. I could fall into the wetlands of the desert. But this doesn't stop me from what i feel. As the moon rises amongst the village the people gather to cook. It's a way of life for the hearty ones. They choose to enhance the senses with taste. A chain reaction of feelings projects into the meal. They eat it and continue the journey down pleasantness. They made it a day which this will happen. In the quiet corners of the big city called the woods. At night; it is dangerously safe because it is natural. This is the crazy place that don't seem to have the ideal dramas the humans think is purposeful.

Sweat running down the mountains, fear in the eyes of the clouds, guns smoking in the trees. People walking like ducks with wooden shoes on the thin ice. Who will sink, who will fall. Who will light a fire and burn a hole in the ice and cook trout for the

evening. Who will yell loud enough to spread the clouds and let the sun shine in? No one will..... No one can....... But every one could... Together.

We talk of these times and the normal comes in like the blue sky of lies. It does lie.. The sky isn't really blue. It is red, orange, tan, and gray. It speaks to the minds of the monkeys as if it was the wisest thing around us. It may be all around, but it isn't wise. It just breaths like so many who do the same.

I walk past the bush which looks at me the same way every time. It has this bushy eyebrow angry look and never changes. It reminds me of some government human who pees just like you and i do. But for some reason still thinks it is much better than all. For the few seconds of peeing several time in a day. It is forgotten by the very pee brains of the world. But i don't forget... No, I remember that more often. It's like putting a blow dryer to shrink wrap.... It all shrinks to nothing with the right amount of heat. But pee brains have sold the blow driers to point their noses some where else. So we never know.

So I'm loose now... Let's let it roll.....

I hear a sound from the moon whenever I look at it. It's like the smell of fresh sheets blowing in the wind on a summer night. It rubs my skin like women who loved from the late 1800's. Nothing but a ghost today. A shadow in the hearts of empty space waiting for her to come home. The modern woman will hurt long enough in time to realize that it is okay to be a woman again. When did we make EVERYTHING a competition? When did family become a sport.

So manly now, so sad really. It is the accepting the sewer as a destiny of thought because they no longer believe in the ghost. The spirit.

Hey, guess what? We are going to die.... So to spent a lifetime willing to smell the decay of dead bodies and be okay with that. How about smelling fresh sheets blowing in the wind on a hot summer moon lit night. It's all how we perceive it, isn't it?

If a sound of a violin was endlessly caressing your day. If the beauty of chimes in the wind were off in the distance in the middle of a business day. Would you do business differently? Would you make things happen that walked the win win path? Or is it the professional suit that is put on. The worrier of today that spanks the idea of reality into the minds of those with less expensive suites. Will it be the very you who spends the hours in business for the shorter amount of hours in living which dictates the idea of living? Procrastination really. You are losing it..... You have gone insane. I know, I've been there. And now I am here floating in the abstract world of dance. The flamboyant bouncing mind of why not.

Can you see past the idea? The tragic epileptic insanity of what was taught to you? The idea of right in today's designed format of rightful doing? Can you jump into a cold pool of water without being drunk? Will you hear the birds in the morning as your wake up is running down your face of fear. the romance you are having with purposeless direction that has

no love. No heart.... No robot with a soft hand to..... feel. Have you not seen what was sold to you? Can you not feel the women of the ghost rubbing your face at night? Isn't she what is taking you away from your marriage in the first place? Do you not see this? Oh.. But you feel it. Yes.... A dance of death in the heart of purpose. A willingness to not be apart of anything unless it is for the gravy you make. The slop you call a meal. What you have and what you have done is desecrate nature by infiltrating nature with technology. Evolution of nature to science. the dumbest people in the world have found the simplest devises to dictate God. So dumb that they can't even see that it is all here for them to change because God is the light. The VERY..... thing....... that you try to change. so do it.... And may your hands be the sap spilling the trees of their life. It's gonna happen.... You know why? Because you will continue to be impressed by the simplicity of sciences, and not the pieces.

I grow tired of the fight between a deep feeling of love, and the constant numbing energy of

nothingness grasping the energy of the tides. Casting a shadow of darkness which numbs the ocean in sight. It is the fight between the mind and the heart. It is bigger than the ocean, but we don't see it that way. We see a shadow and stop there in fear.

What would it be like if you took one candle and floated it out into the shadow casting in the ocean. Would your science say it wouldn't be bright enough? Or would it be just enough to change the prospective completely. One light..... One candle. And it danced on the waves and survived the current doubts. I would lay on the beach and watch it forever. I would feel the sand in my hands and see the storm thunder in waiting for the wind to blow the candle out. I would realize the ghost, the spirit of this moment. I smell pine and rain. Cedar and juniper. I warm fire on the beach, and people lit up with the orange light of camp. No reason, no idea.... Just the vision... Just the storm. Just the candle floating started it. And the rest never happened. How amazing is the light.

02/21/2013

Obstacles of thoughts mathematically limiting the possibility in the never ending place of space... Not to mention that math doesn't end either. But we do... We as in being our thoughts. So tired of trying to makes sense out of the hugeness all around with limited words. It is like throwing a dust mite into space... It exists, it matters. But what antimatter's?

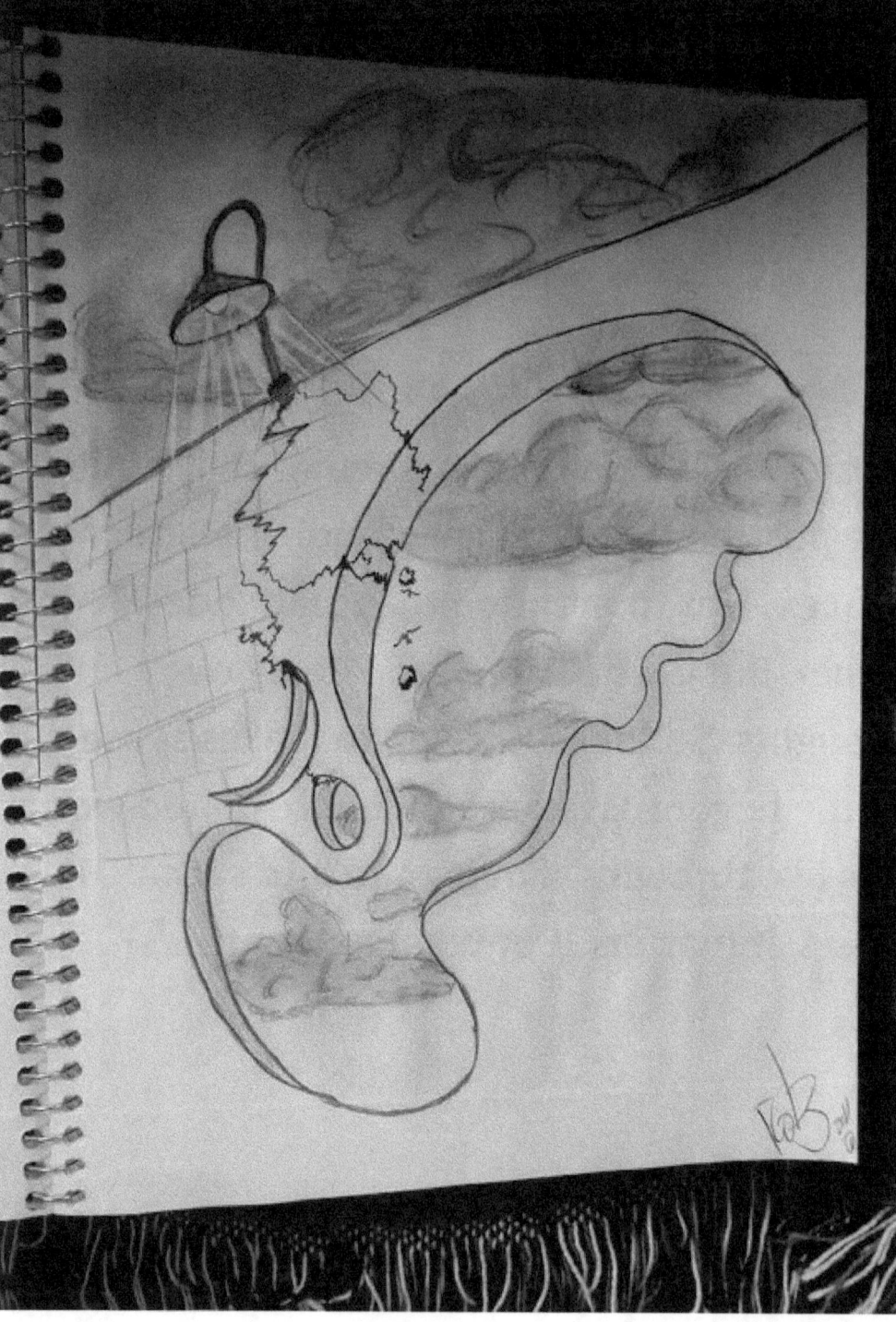

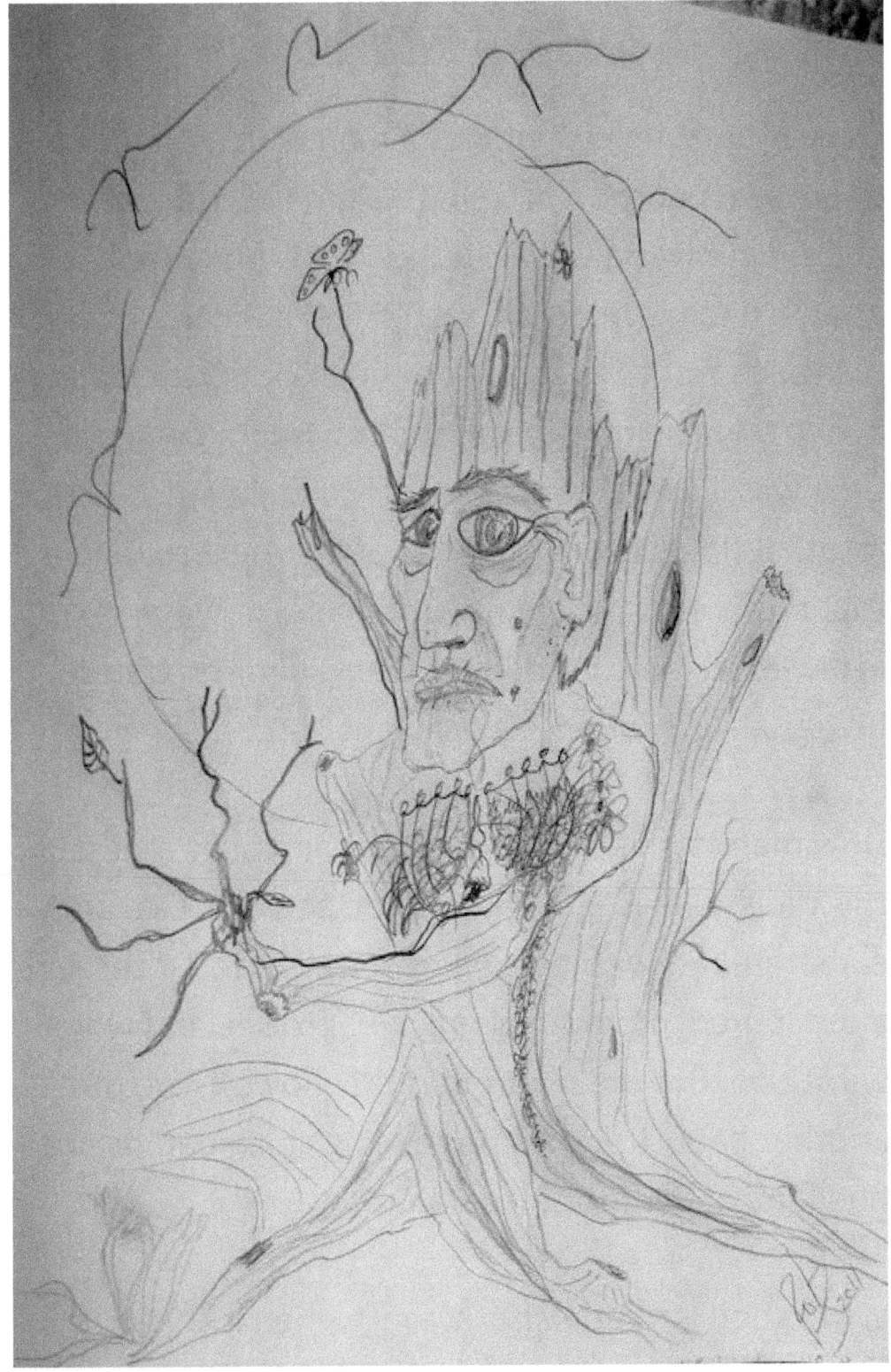

RAFTING WORLD

Once upon a time their was a man with a mind that only used a portion of it. In this time of using his mind, time was always illusive. As his body is attached to his mind, he would feel pain and pleasures from the surface of his skin, to the foods he would take in. Young without wisdom because time was illusive, he was taught to build an elaborate raft that floats down the river of life. He was taught that this is what you want, and this is how to achieve. As if he has done it many lifetimes before, he has always found it a constant bore.

How many times must we except and believe, that this taught life is 'the' matter you achieve. Like an elaborate raft with a reclining chair. Huge TV set and a out 'bored' motor deciding what to see and which way to be. But the river of life still flows as we drink another beer sitting in the relining chair, damns are built ahead cutting off the flow.

What good is your elaborate raft when it costs

money (Which equals your time) to pass the damned up tolls. It is not corporations or government, it is the 'hole'. An entire people who still believe in the raft as the ride, as elaborate as it can be. To pass thru damned up tolls and buy bigger screened TVs. To only see what was controlled even though the river continues to roll, regardless of the channels they flipped thru, which becomes you. Yet... nor the river or the broadcast-ed stations were ever in your control. Rocks and weather would be reminders of what isn't in your control floating down the river. Just push to make your raft even more elaborate and bigger to weather the river. But it cost you more to pass thru the tolls dammed up by a people who say..... It's just so.

The obvious is never questioned, it is always avoided. To except that life is just the raft, and the river is just a river. Even though we float from the beginning to the end. Make it a joke and poking sharp sticks, deflating our own float.

After elusive time continues to crash each raft.

Ending up on the shores building yet a smarter one. It crashes again and again leaving this man in the water learning to swim. Until one day he begins to question the river itself. Looking and feeling his own venerability IN the river of life. He stops swimming from exhaustion and discovers that he can float.

The elements within the river are exposed to his skin. He drinks the water like never before because he is now taking IT all in. He decides to just float for a while as he passes another man who pops his head out of the water with a big grin. Hello my fellow man, and thank you for coming in. This man with the grin says to him, what are your sins. I don't know grinning man. I just know that the river is cold on my skin. And that I am afraid to submerge deeper within.

This is your life, the river, what is above is the elision. The easiest way to avoid the real way was to believe in the illusion. Their is a fine line between what is above the river and what is below. You only chose to build elaborate rafts to float on this line as it's taught and passed on. But the more you avoided the river,

rocks and storms became bigger. Ending up in the river each time has you question this fine line. And swam to shore to build even a more elaborate raft. Each time it because even more of a bore.

And then logic would dig deeper and you would become another damn builder in charging others who floated on rafts in the river. Damns can never stop a river, but only slow it down. You are here to question the entire picture above the water AND BELOW. And now that you are in the water, let me show you what is below.

At first the man retreats back to his taught fears. Below is hell. Below is to deep.. Below is dark and cold. Below you can't breath nor see. The grinning man ask him, how will you ever know unless you go. You are half way there anyways. For this is only your MIND and not the river. Don't believe me nor what I have to say. Just look in the water, hold your breath and see to BE. It is not my job to pull you in. That should be only your sins. Now that you float on the line, you feel them. How can you be okay always

swimming away. Time will bring you there anyways again and again.

He holds his breath and submerges within. Already the sounds have changed, more muffled and distorted. The smiling man just encourages him. He feels this quietness as he sinks further in. But fear has him swimming up to the top again. Grasping for air and confirmed his fear. He tells the grinning man that it looks dark down there. He can't breath nor hear anything up here when down there.

The grinning man ask him if he would try it again. He says, now way in hell. I'll just float here until the very end. The grinning man smiles again and says, before I leave just realize this. I didn't meet you when floating on a raft, nor on the shores building elaborate again. You were once afraid of this and now it has become you. You are now in the river no longer protected from what is below. It is only your mind of the majority as you already are afloat where they appose. But will you find contentment and peace swimming to the shores building another raft. Will

you try to sell your referencer to others about floating on the line. Or will you see the truth about above and below. Only you will ever know. Good day my friend. And thank you for trying.

The man swims back to shore and starts to build the even better elaborate. This time a house on the beach.... He feels wiser and posts a sign along the river for everyone to see.... I have seen what is below...... But no one is stopping to question his exploration. So he builds a damn in stopping them. Amazing how fast he progressed in building elaborate things. This new found wisdom in only seeing what is below has given him a false understanding of what IS the only reality. Be he truly has never seen.... But not many go there, so not many can dispute it, nor do they care...

He spends more of his elusive time damming up other minds. Forcing others to read his sign. But realizes that what he saw, what he tasted, was only 'thoughts'. For the vision of what's deeper in the river of life, looked black in his mind. This is what he

sold to believe. He realized that what he was doing was encouraging others just to see what he didn't truly believe. It never filled his cup up. So he ran to the river and jumped in..... It's time to realize the truth.

He strips his close with no hesitation and jumps in. He submerges his head and starts to sink to the bottom. As he drifts slowly lower and lower. Sounds of rapids are fading. The suns light is dimming. Lower and lower he feels the current slowing. Until his feet touch the sand at the bottom. It is pitch black, he sees nothing. He hears no noise but feels a fear of the unknown. He is willing to let it go, and to be no more.

Like walking in a dark room, you see nothing at first. And then all of a sudden a table appears, and then a chair. Seconds later he sees everything in the dark. He sees for the first time..... His mind. This is meditation......

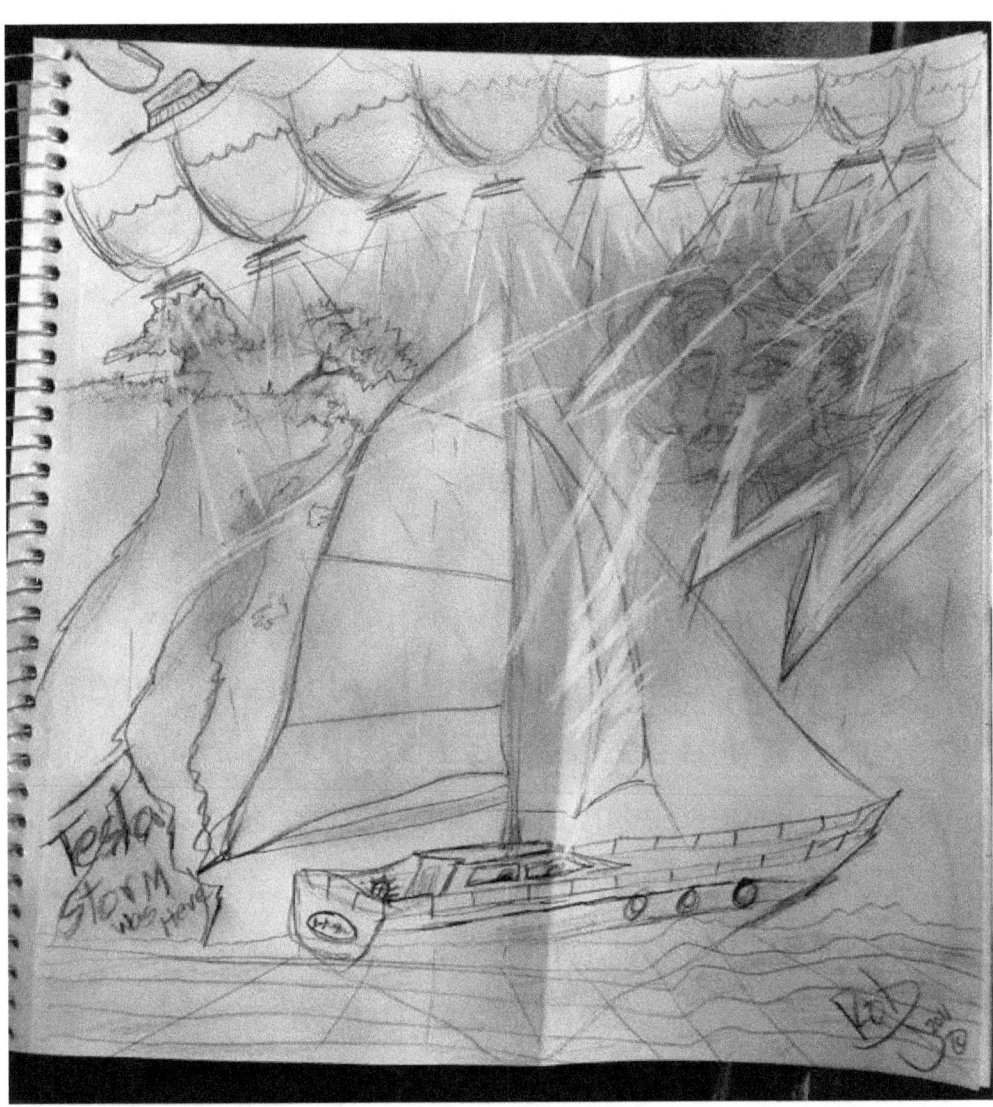

THINKING

We think we are our thoughts, we think we are what makes us feel good. We think we are our stresses. We think we are that little voice in our heads. We think - thinking is how we make decisions. Yet, it never was.

A motive is felt before the thinking ever arises - You have already decided. Thinking is a fantasy island between felt and action. But we think to long and we actually believe we thought it before feeling it. This is ego. Thinking takes us into a database of history with only two motives. To gain pleasure or avoid pain. Thinking wants to manifest a better future. Thinking

finds ways to convince and sell a manifested world. Thinking has us believe that there is some kind of path to total clarity, or inner peace. Thinking is the distraction. Stay to busy and distracted to even have time for contemplating this thing called thinking. Think about thinking... What is thinking. Is it really you?

Have so much time for contemplating and questioning thinking thoughts. That you evolve on the other side of thinking, which brings you back to the here. Then you realize that you were never your thoughts, because HERE is always ... just HERE. The same place you stood in thoughts being swindled by thinking that there has got to be a better place. And HERE has already given you everything you could possibly THINK you need. For if you were just here and had faith in the present moment unfolding. You would clearly BE who you really are. AWARNESS. You become the awareness of thinking, that something capable of seeing just the thinking. When we make a connection with that and the eyes are opened. You become aware of everything that you were not

aware of in a previous life of thinking.

You learn that thinking is just a tool and not a lifestyle. You also learn that thinking is okay if thinking is what you enjoy to do. You learn that none of this even matters. Because you are HERE. You can manifest dreams. You can feel stressed for attention. You can feel depressed. That is only your idea of a person. In awareness you aren't YOU anymore. Their is no you.... Just a being floating in this dimension of reality. The freedom is the awareness of your permanents... You have always been, and you will always be. What guides us thru unfolding moments by moments is heart. And that can be explained like this.

_____. Their are no words. You don't even have to fill in the blank. That's a person trying to make it personal, and that's exhausting. But we can also return to thinking, even in awareness. But now you are at least aware of awareness. That is an evolving mind that naturally will take you completely out of thinking with time. Then it becomes

wisdom.... Within wisdom ALL good things are built in – and you see that their was no reason for thinking. Your life becomes the heavens you were thinking you have to go somewhere else to realize. That you ARE FREE.....

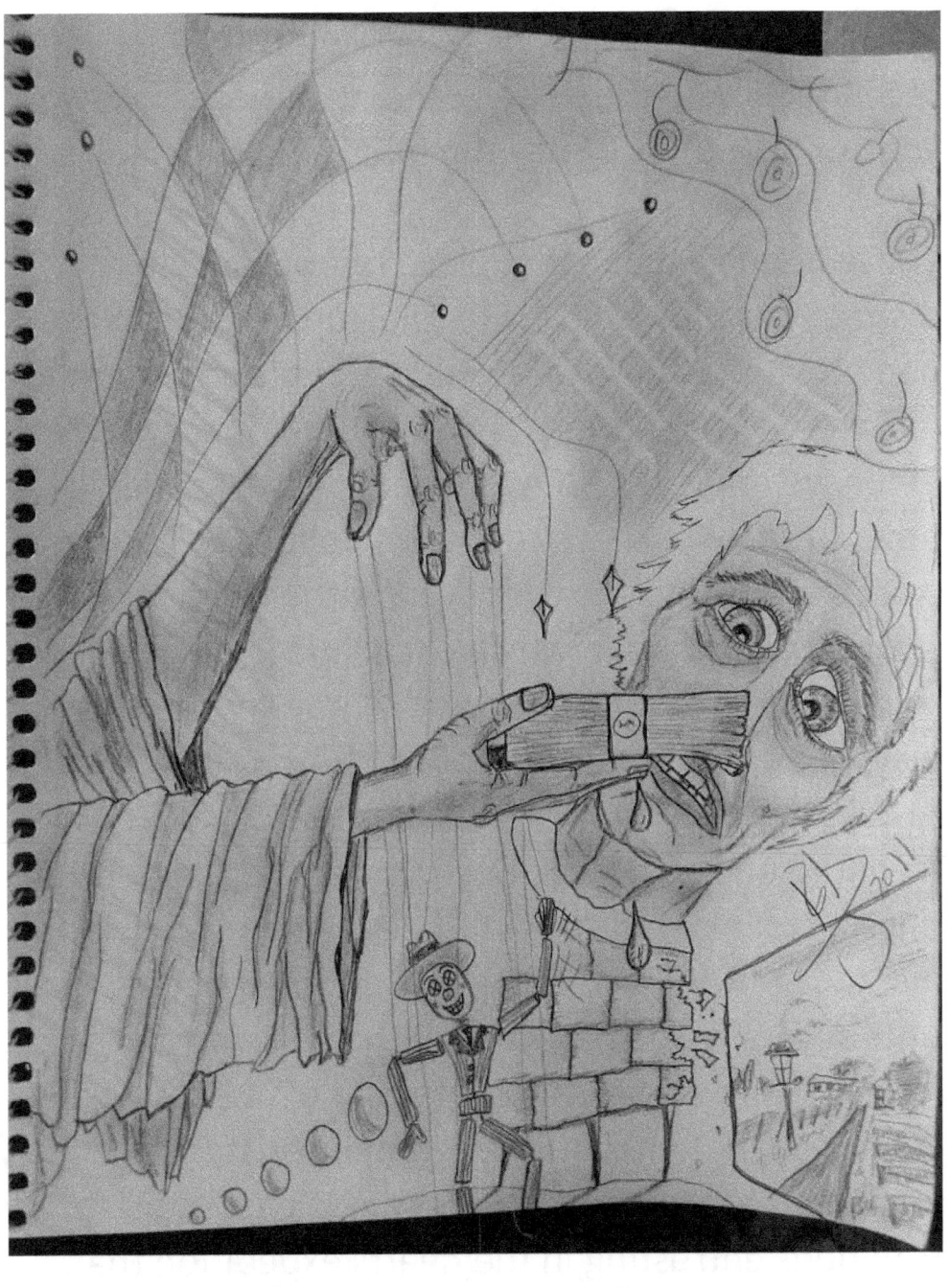

I have to do my laundry

9/08/2013 - It has been very difficult this time reconnecting to the understanding of peace is always surrounding us. It is only the mind that suffers.

I have been given a quiet place removed from the distractions of everyday life, the good ones and the bad ones. The companionship of family and friends and the constant duties we have unfolding everyday when we are together, work and pleasure. The bad news of the world economically, politically, and the wars this planet sees every year either ending or starting. The ways in which each individual decides to deal with life as I can see why they choose the ways they do. Humor for not so humorous moments. Always deep when the time is for humor. Closed off from the energy of love one moment. Open to it once again most of the time seemingly to late. Or just doing the "right" thing and not questioning it until several years pass by and the wake up call rings loudly. The, I guess it's just life isn't it?, becomes the stopping point in learning a grander existence. To learn how to step outside the minds passed on traditions entrusting in the hearts expedition that unfolds only without expectations of a life.

Unconditional clarity, or the path of wisdom, which has love built inside of it. Why would anyone even choose such a catastrophic change it seems to the naked minds eye? To confront your mind and see how it has been dictating your everything!

My first week reentering a path of introspective understanding without the distractions of the minds idea of life, and societal structures, has been very difficult. I have done this before and I have forgotten the difficulty in taking on such a task at first. Since my time has started last week, I have faced my mind once again realizing how I have been living out dreams I mentally manufactured, and how easily it slips back into our lives. There has been a battle going on in this small 600 S.F. Art studio that was built over a hundred years ago.

As the old clock ticks in the background and the smells of an old building lingers endlessly no matter what you do to mask it. I have found myself restless and lost once again. And have taken up drinking 4 nights out of the 9 to the point of sleeping most of this time away the next day. I wake up every morning with the desire to run and lift weights, stop smoking, eat even better, and improve my life with the

externally obvious right directions. And the physical health we all deserve. I didn't see this coming. I THOUGHT I had it all figured out.

Now I remember the last time I did this and how easy it was to let all these things go. It took 4 months, it wasn't easy. I'm on the right path now, the painful confronting is what most people aren't willing to face. And that is YOU and your own mind and how swindling it is. Coming from a lifetime of being in the motivational seminar business, sales, sales training, and business operations/ownership. My mind is the biggest asshole of them all. It can talk me into just about anything it wants, and is quite the closer... on me.

I have put my mind in jail as of now as I sit outside its cell with a pad of paper and a pen studying its childish criminal ways as it has robbed me to long of the simplicity and innocents of my truest being. It has robbed me of my best moments which is always the present moment unfolding. At which point I now find myself writing what you're readying now with

honestly and heart. This is the good news. My awakening is coming again with each word I type (Typos and all). This is the ME behind all of me. And all of you who are apart of me.

I came here to paint as I felt and needed to. I asked God, the universe, for this time with mental images of a different turnout versus the one I am confronting now. As always, no matter how free you are. It will never be as thought out. That only comes when there is no more thinking. That is when you say, it is everything I have hoped for. And I can play with this understanding on and off all day long. Meaning; I can think one way and feel the good. Or just add a twist of another thought and the nightmare appears once again. Which one am I? I am the one noticing this, that is who I really am. And the freer we are with time to study this makes time for the study of this.

What are people wanting a lot of money for? To buy things? Or maybe subconsciously the freedom to face there own demons. But when the freedom is

there the true suffering appears, and the drinking begins. Or sex, drugs. Some face the contemplation of suicide. Or manifest a sickness.

This is why it is very difficult to face your mind, the only reason anyone suffers. It is the mind and what it believes. To stay busy building a life, or helping others with there own life is purpose. But to much is a distraction from facing this inner demon we are owned by until it is noticed. What would you build, and how would you help others, after this understanding is confronted? Some minds are more tuned for wisdom versus intelligence. There is a difference. But all minds will in time become more wise. The more intelligent you have , the closer to death is when you'll see it. When all intelligence did was be smart enough to avoid facing the biggest question in your head. Who am I? And not who do I think I am.

To be continued.... Or not. I have to go do my laundry.

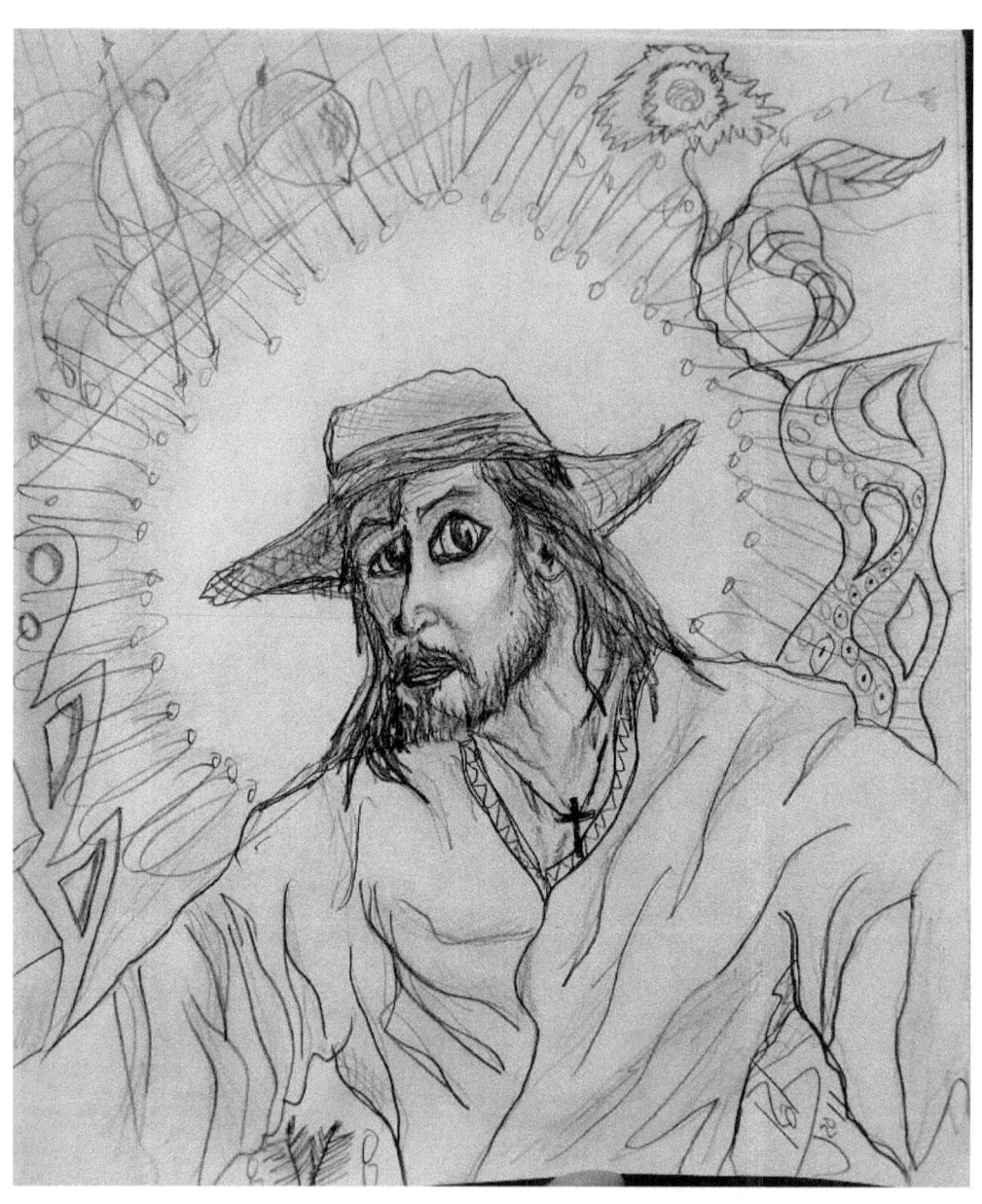

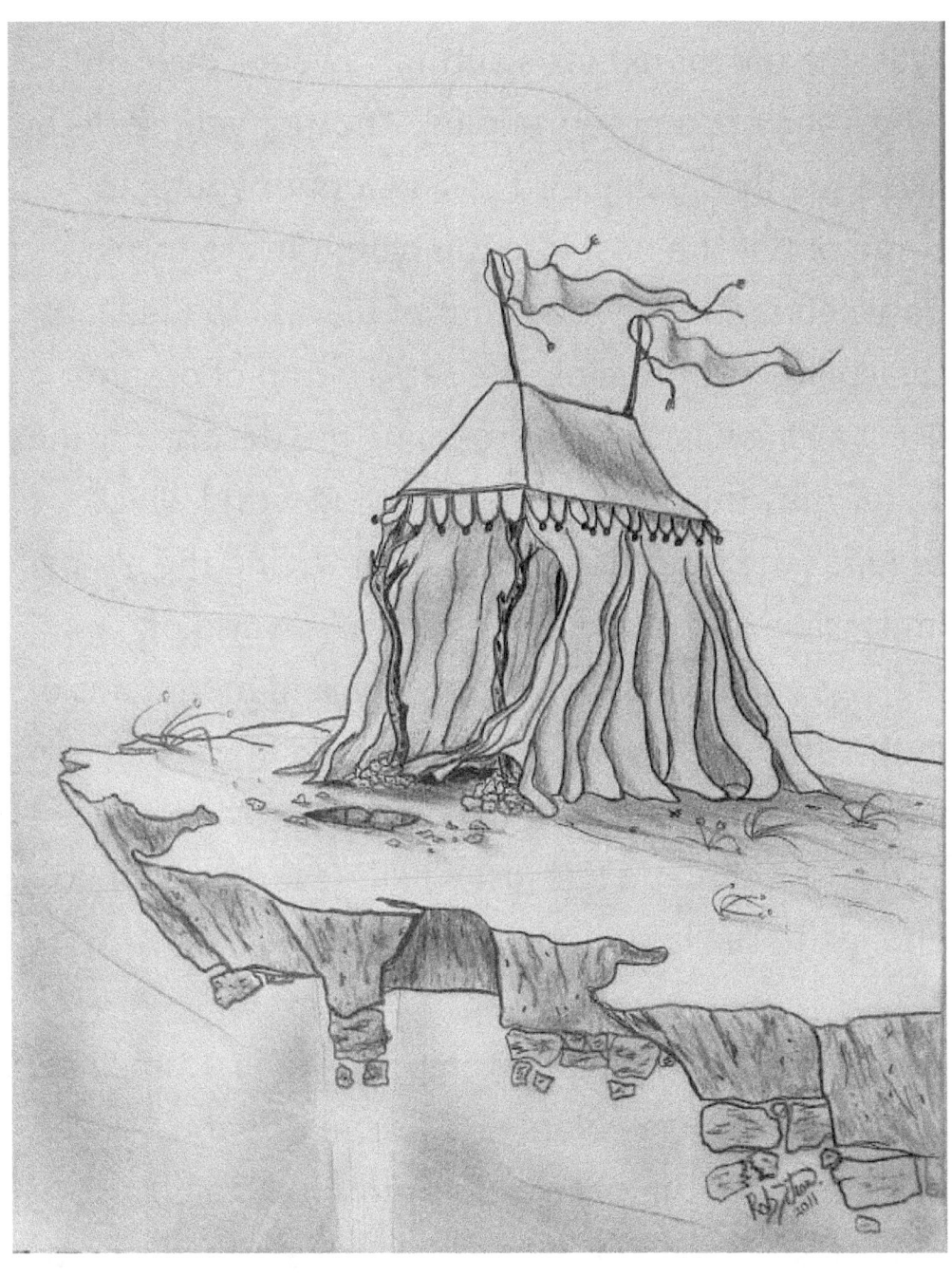

The Autumn Scarecrow

Washing my thoughts as autumn sweeps over the landscape of summers ending. Another year sores by like a swiftly passing bird yelling for her young to come out of the nest into the blue. We are torn between the realities in front of us, and the feelings they play in our bodies. We see a world of dreams like walking wise Indians roaming the deserts for the water they thirst for and need. A big world which requires the attention of the spirit to find the almost impossible locations to drink from. A world of feelings and thoughts are the cliffs and mountains off in the distance. So big, so hypnotizing in its trance of illusions, the bigger they look from a distance. Dance at the foothills and it is just a hill. How do we bleed enough to realize what is here and what isn't.

I am propelled to sit and watch for the first time as the leaves change colors. Clocks can't be the drummers for the pace of this motion. Snails can't move fast enough in the race of space. We just crawl to the next awareness in reality, our space. A lonely

journey of truth disappearing with every conversation. Even the wisest can only say these things in a moment, and then it to passes. The prevailing winds carry the sight we seek, but lost in our thoughts as we make a fire for food. Feeding off of the animals and plants we scream. Why must we eat in this vast energy and space? Why must I take from the living to continue my journey? Because it is all a lie, and it must be fed.

This human suit I wear in the cold and heat. I can dance and sing from my soul with this clumsy tool we call our bodies. But make it bleed and I'll show you a fountain of death just around the cells. Inches away we stand in this shell at the mercy of faith and our own God who prances in clarification of the dirt. Kicking it and creating a cloud of soil. The fire is burning hotter and higher. Sparks swim into the air for the nearest tree. Will it become a fire? Or will it fade away as if nothing ever happened. These are the things our world is made of. Predicting the outcome of just a spark is the power only the ego can ever claim. Say enough events and one of them

will be correct. This will be claimed as the wise man sings a song of so many different tunes. One will click, one will make it seem wise. But still we never know when that leaf will fall from the tree and reach the ground. For the tree is the wisest, no thought is ever around.

I wake-up and my body feels pain after a restful night. Not until I move it's limbs and get the rivers flowing will the logs creating damns break apart. Down river they travel and into the lives of millions of cells. Feeding off of these living things that were taken from other living things we collect its sunny charm. Feed for another day and just maybe you will live long and tired. Accomplish nothing more that to see the sunset everyday. Wish for the sunrise as the spark of the future plays for a day. But still we don't know if a fire will erupt, or will it dance away into nothingness like a gypsy hunting for happiness. All we can really do is dream and feel blindly into the blue sky. Lost for anything to really hold on to. This is the power of the soul which harbors in a sponge made of biological science forever and never totally

understood. I am nothing more than the leaf on that tree. This is realized only in time as we fight for understanding each others motives. But just maybe the most clarity is when we are falling from that tree to the ground. However long it takes as the prevailing winds carry our sails of hope horizontally across the sky to the ground. In time we all reach the soil, and then we become it.

This morning a scarecrow came knocking on my door. He had a bag of goodies for the autumn celebrations. He opened the bag and black crows by the thousands came out like a fog of darkness into my eyes. They found limbs in my mind and made nests of thievery as they hunted for anything shiny worth it or not. Pack rats of shinny things as they swarmed around in my never ending thoughts filled with a world of dismay and hope. She showed herself to me but only with words. I never had the pleasure of feeling her skin next to my face. But I was brushed by the crows lost in the hearts of many dancing under the foggy skies. Marshmallow treats melting on chocolate crackers we can taste it. But

making it becomes sticky figures of lost time and tractors plowing cornfields of gold. Just nothing but the time we plow away for the sake of hope. Everyday we hope.... But some days we know.

The sun is now setting and the air is clean and pure filled with flamenco guitars picking every string of insanity. Walking to the next cord as the scarecrow leaves off into the sunset, he looks back and laughs. His face swells up with fire and spits out a glowing ball of heat and flames. Dancing his hips side to side and spinning with joy for the winters are coming. A black horse picks him up like a well fit bus station transporting dreams and hope off into the night sky filled with music. The mysteries of that moment will dance in your mind for many years. Some nice sleep will be deep, other nights will be a candle glowing in a window. Entranced by its moment of style, we feel again and that's okay. But we can't ever become the style, it wasn't ours. But it was felt, so we make it ours. And so the self is lost once again. Distracted by the moments of others who shine in the moment. When will we shine? Will it be as amazing coming

from me as I see in others? I don't think so. It comes from selfless behavior, and that's never a fun time. But it does warm the hearts like a well stocked fire in the stove. Cooking stew for the winter snows falling like angels coming the visit. I have warmth for you, come into my heart. I will wrap you with a blanket made from my grandmother. It comes from the depression of the 30's, so you will feel sadness when I drape it around your soul. But it's warm and about love. Love is everything the comfortable avoid to feel. Fear is nothing more that the nothingness sold to us by the enchanted ones. As if their isn't anymore space for the truest of love. Love is felt on the tip of our wings we can never see. We are all angels dancing for hope. We fight for the truth lost in conversations and rules. Shed a tear once more.... Love will be on the droplets from your eyes. Don't be afraid to show the world your belief in something that can't be seen. Your wings of angels are there, you just can't see it. Move the heart and you will fly. Sit in a pond that never moves and you'll mold. Then life feeds off of you and not with you.

A man stood on top of a log cabin as he watched the scarecrow vanish into the foggy autumn night. His hands warm from the fire below traveling through a chimney made of gold. Every night the chimney would change form. A soft metal molding into whatever the winds would see as fit. Pressing the atom enriched substance with mans idea of value. He waves good bye to the mystery man without a heart. Traces of straw left behind he collects for the morning fire. Something left behind which will become again that spark reaching for the trees. Will it start the forest on fire? Or will it once again vanish into the cloud filled skies as the piano peacefully plays the strings by hitting a key. Are you lost yet? Good... It's the best place to be if you want clarity and understanding of your purpose. And you do have purpose so says the things you can't see but feel. I wont lie to you. For life has already done that for you. Now become lost in the truth as it never makes sense to the mind. But please feel again........ for selfish reasons I need more of the crows collecting meaningless shinny things for my mind to hold. This is the place where dreams come true. I'm forever

yours.......... Wanting your

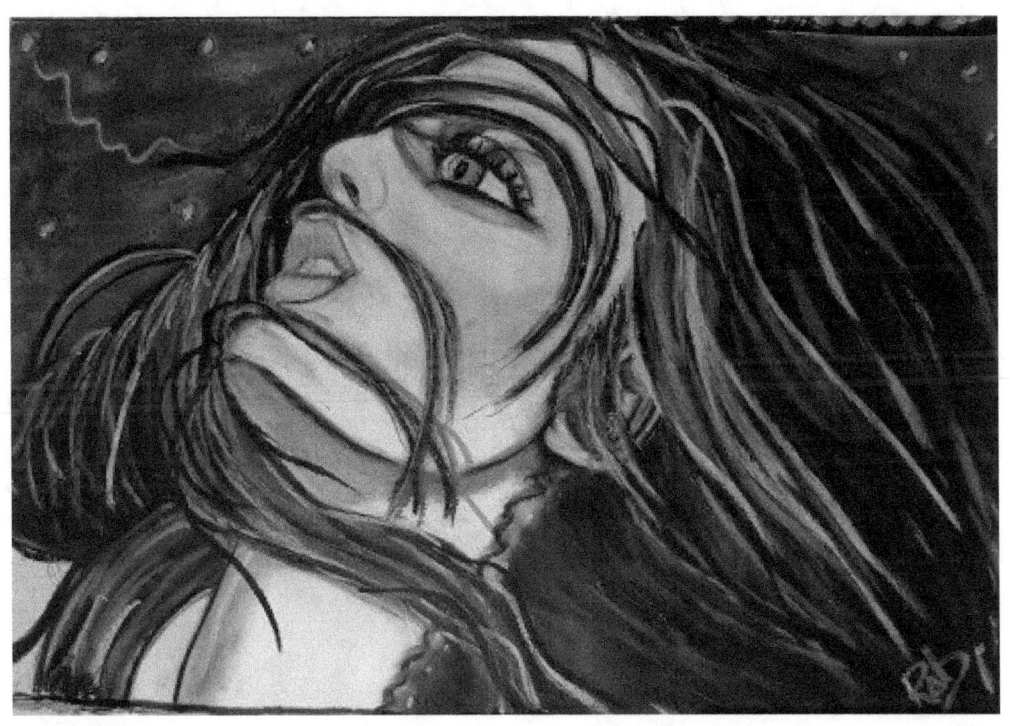

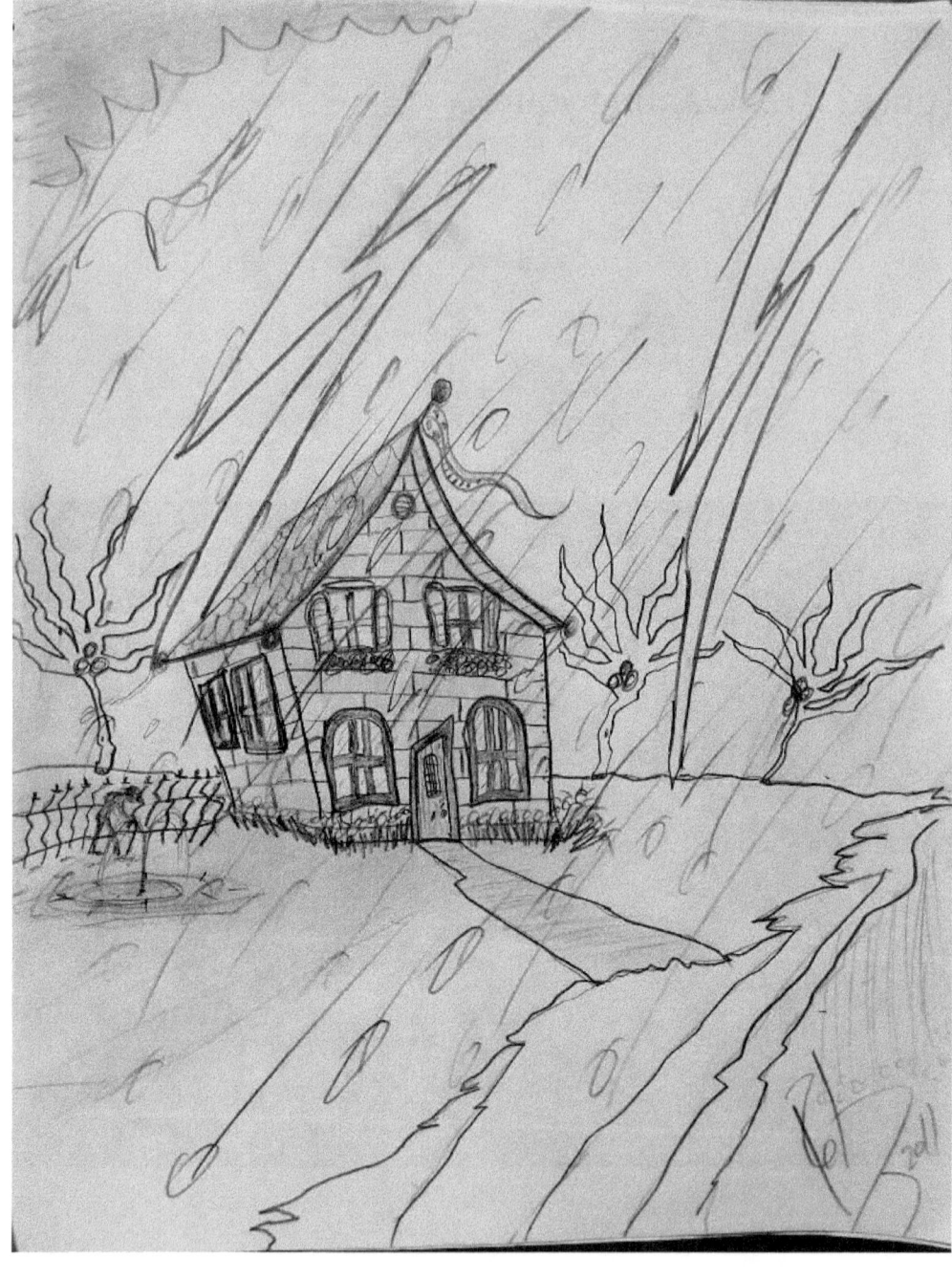

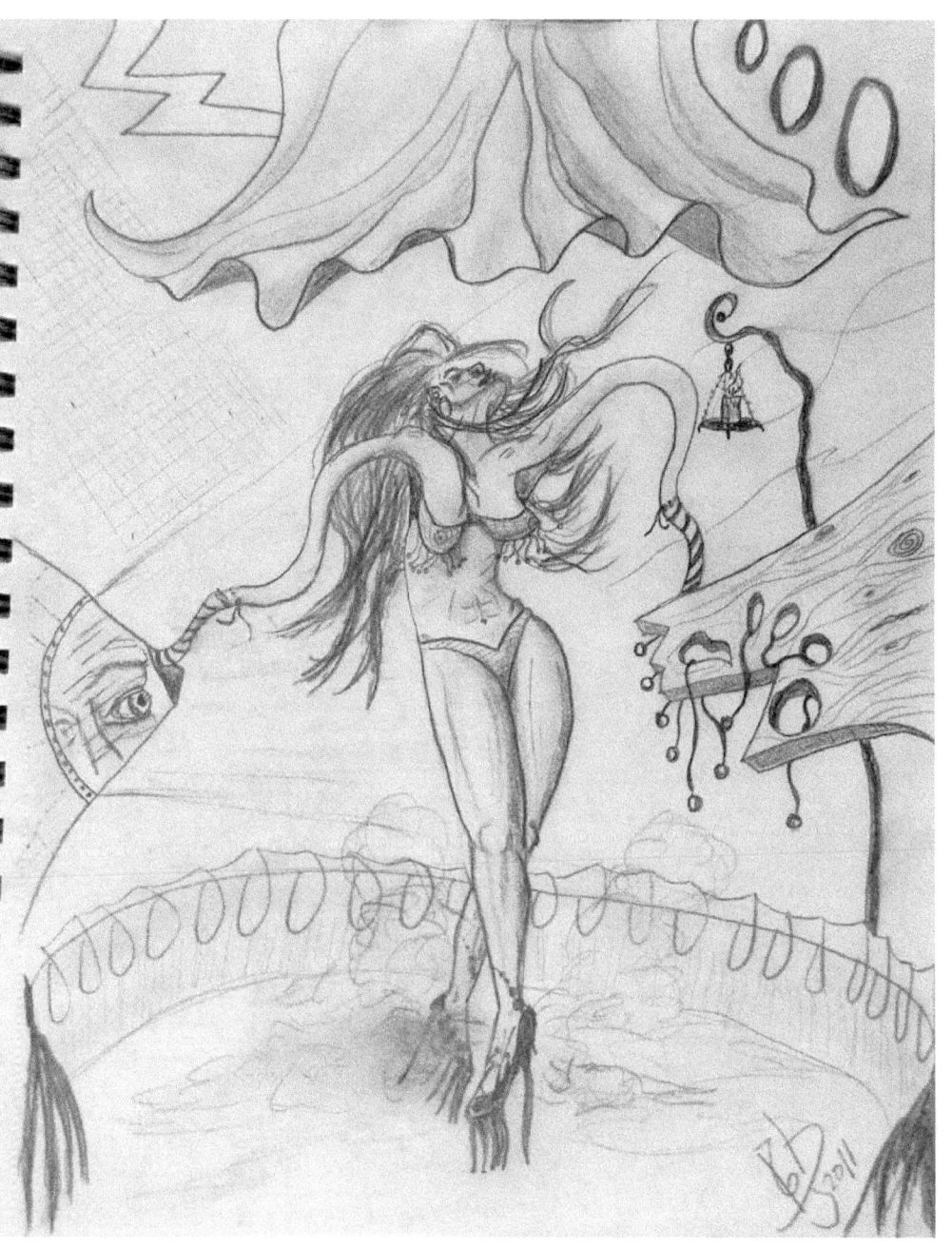

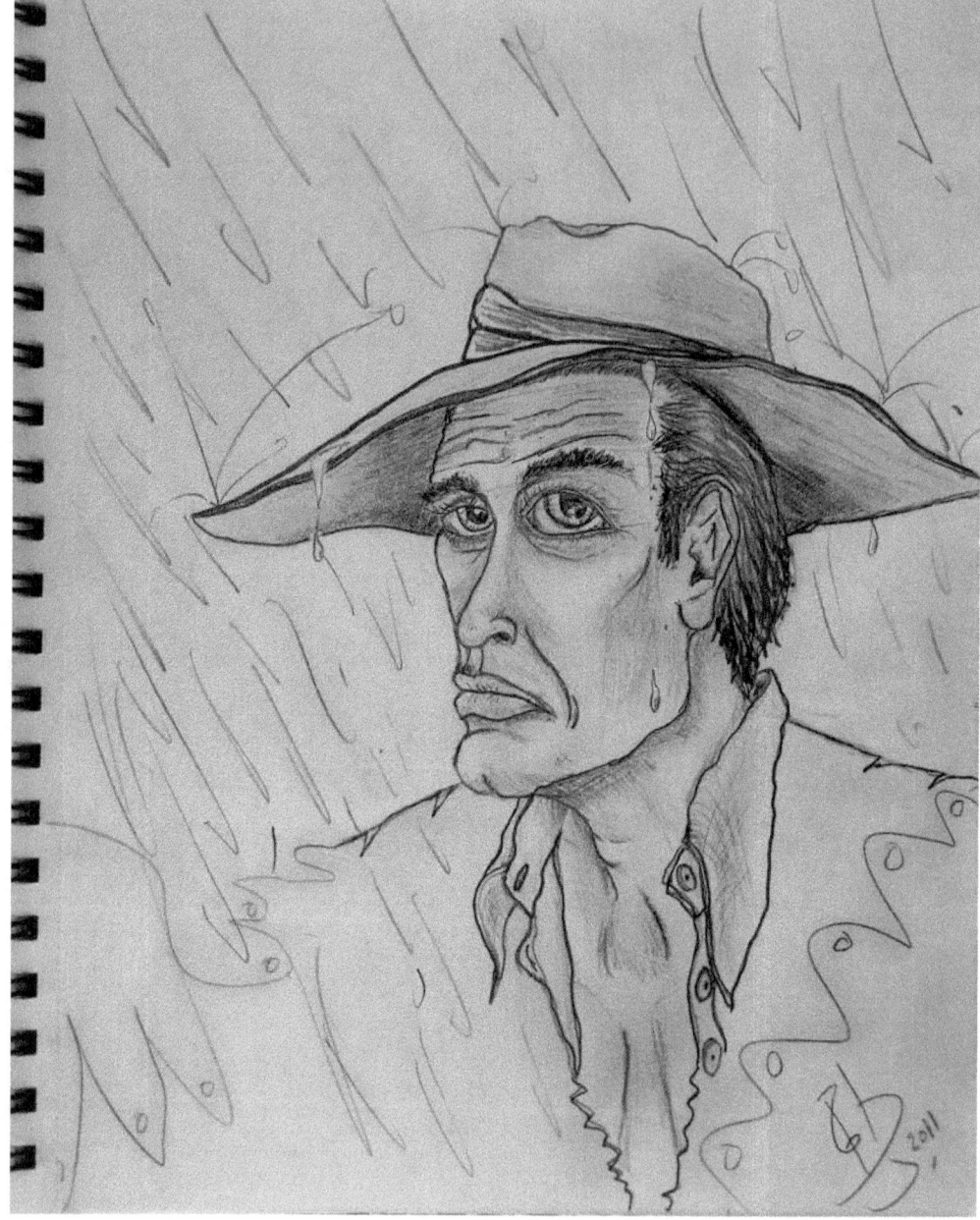

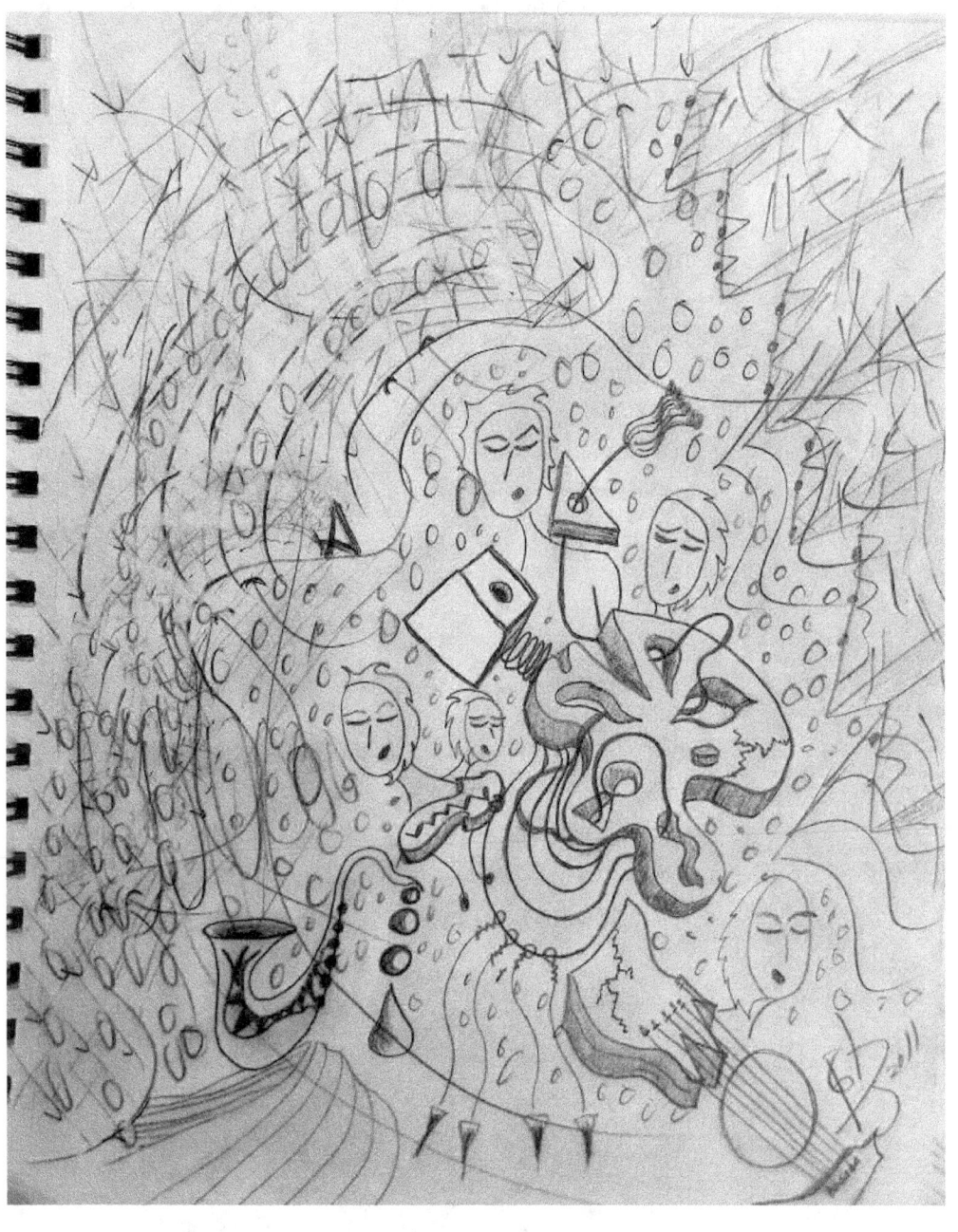

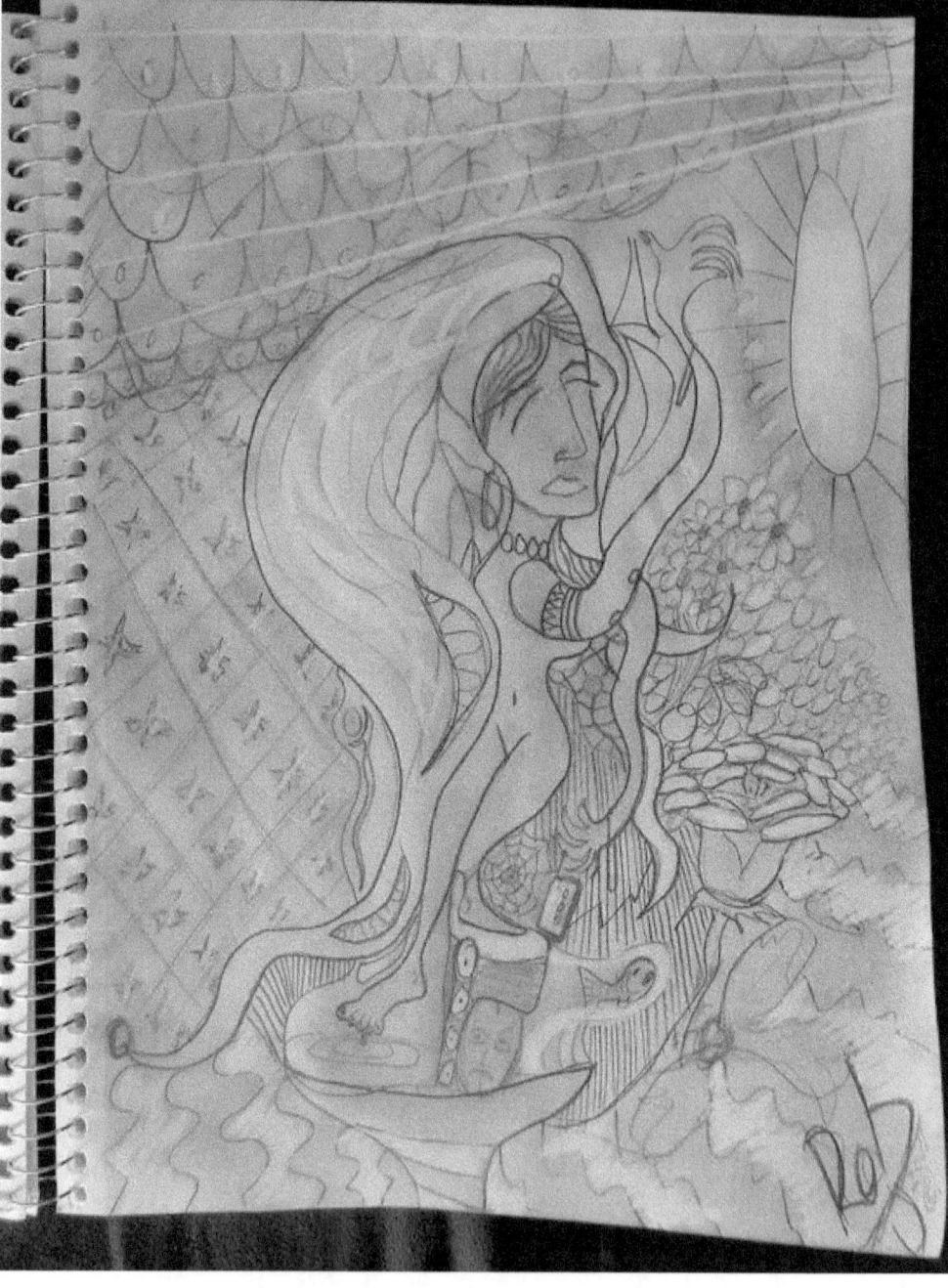

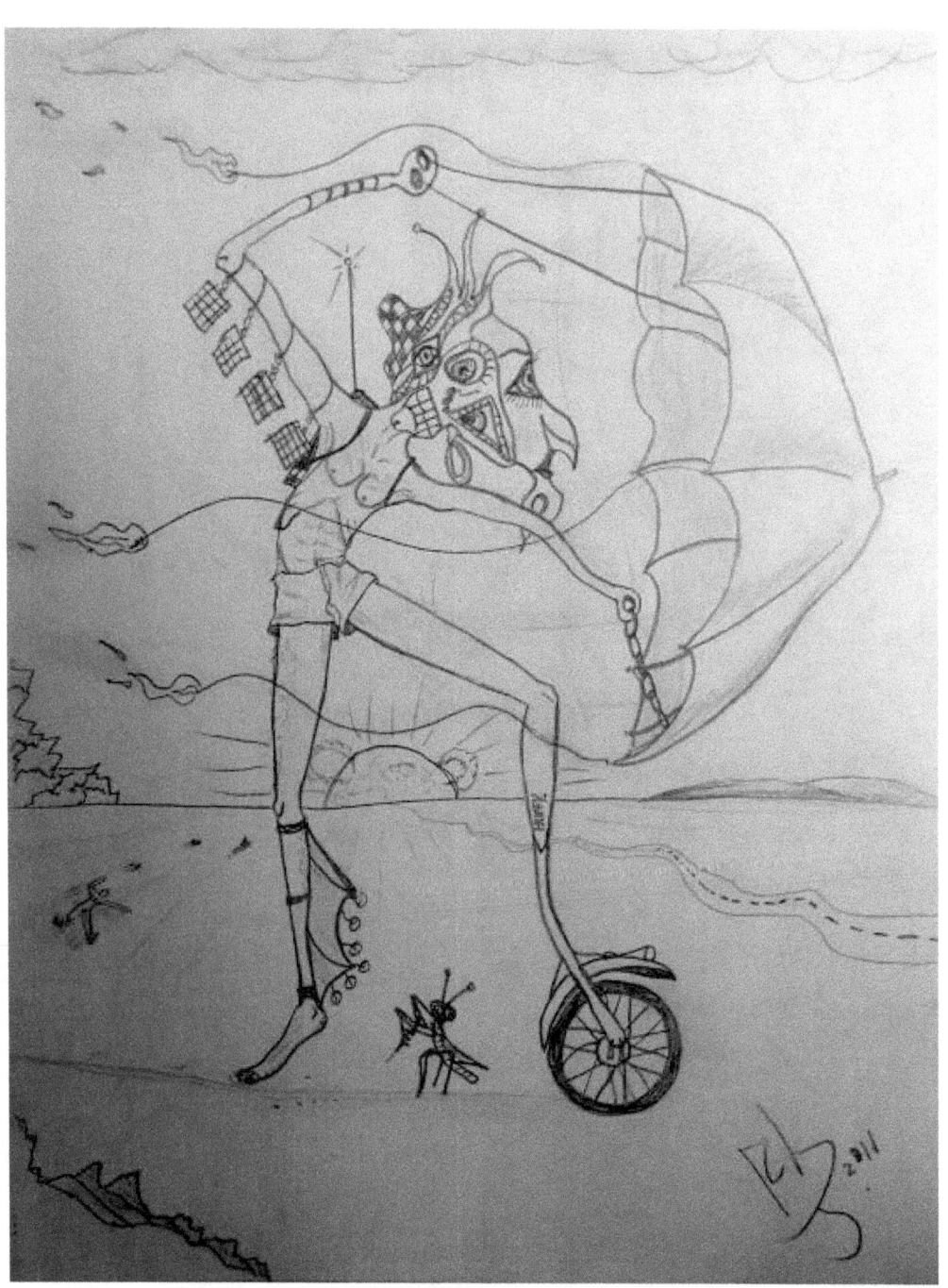

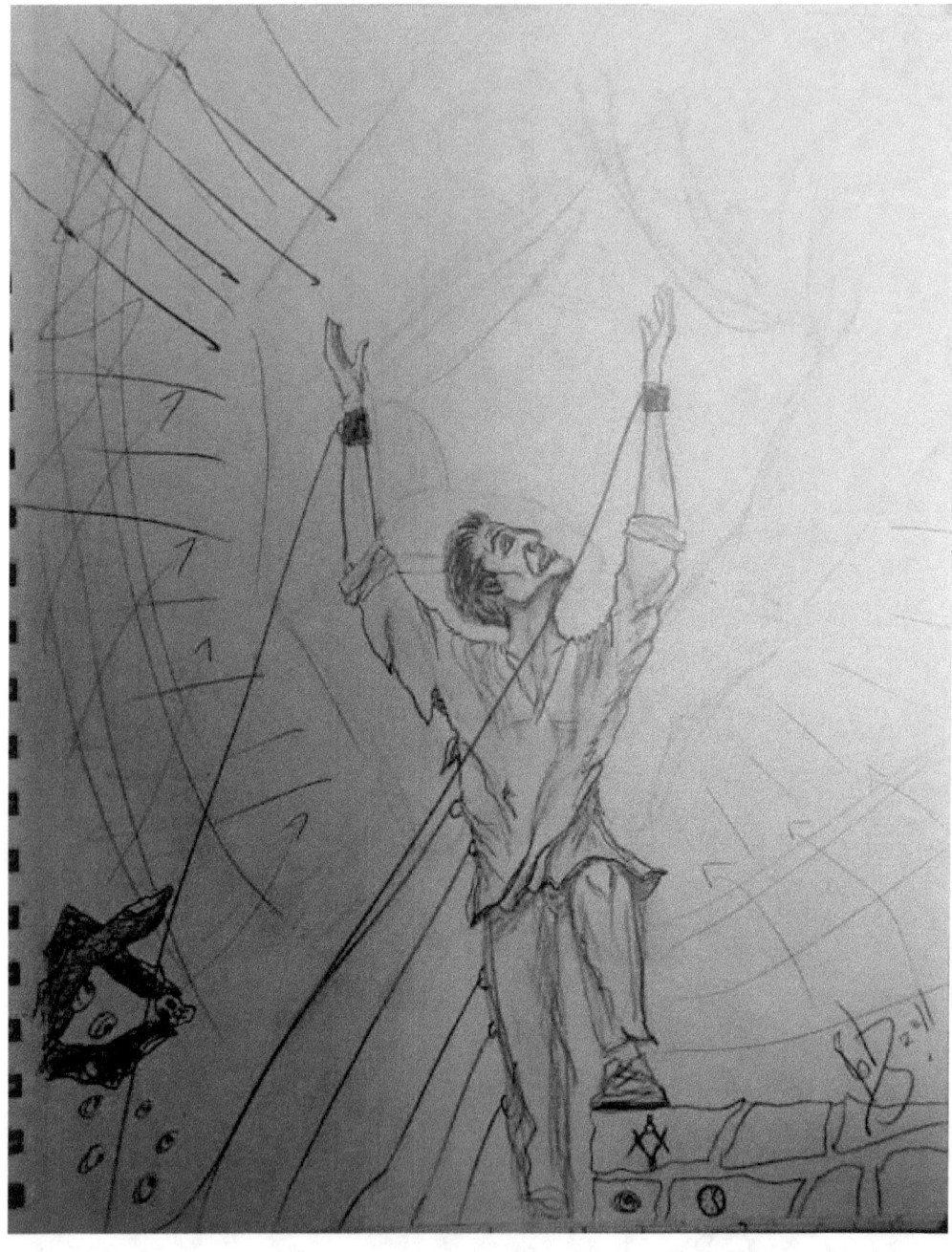

BOSS or Leader
(I wrote a CEO)

I have been "the boss", I have also been a leader. I wasn't really good at being the boss because I have worked for bosses before; my experiences were not inline with my understanding of life. My right to be happy and enjoy what I do without some idiot finding it so important to fill it's ego. It was a nightmare of accepting artificial confidence with egos that most of the working world seems to believe as "the way it is". I'd say that over 80% of companies running things today are running it like a boss. It has even become a slogan today amongst the younger generation, and is considered impressive when in fact it is detrimental to every aspect of business... And life. Simply put... It's ignorance at its best.

Today our nation is being ran by bosses. Corporations are being ran by bosses. How to identify the difference between a boss operated institution, and a leadership mentoring organization, is very simple.

My personal experience as the boss and then a leader has actually been a leader first, and then I became a boss. I built great success at one time as a leader. But when the dictatorship of the factory I was buying my product from, and then the dictatorship of new federal laws against the free enterprise world went into effect. I ended up turning into a dictator as well.

When companies are hurting, when nations are hurting, most people that have had a lead position, they turn into a dictator because they run out of answers. They turn into the angry overly protective soccer moms. They start to create a nanny state within their business, within their countries. Time and time again we progress, and then regress. I think we regress more often. A sure sign that things aren't doing well in your business is when your leaders turn into bosses. Even worse is when leaders turn off communication and delegation becomes a chain of command several levels deep. The more middle people there are passing down the words from "the boss", the more distorted the commands become.

And the less anything really gets done. Until no one makes waves and just complies to … "nothingness". A complete stalemate in the chess game of business. Just show up for work, do your job (As little as possible), and say nothing. And now you have a nation (Or business) of laws, rules, regulations, and a dictatorship of shut up or suffer the consequences coming from even a bigger boss who has a roll of red tape wrapping around the world (World of bosses and not leaders. They now call them lawmakers when it's supposed to be law enforcers who work for The People). This has got to stop! Wake up and be accountable. SPEAK! Recology is your business. And if your leaders aren't hearing you out, speak louder. This is about you and your business. Because it is your business. That's what ESOP (**employee stock ownership plan**) means. You have shares in your business. And if your leaders can't handle such a diverse group of owners and compile a system that allows you to comfortably speak. Then they aren't being leaders. They are acting like bosses. And just being a nice boss doesn't cut it. Nice bosses have tricks up there sleeves. Accountability is the key and

talk is cheap.

I'm sure some of you are reading this now and see no reason for even talking about this. Just plugging along in life and walking the razors edge between keeping your job or losing it. Hell... I ended up not getting hired. So maybe you shouldn't listen to me. I'm even going back and reading this saying to myself... Why does it matter? Why? It won't do anything. Why so dramatic? Why so deep? Because unlike a lot of people I see in life, I refuse to turn into a robot that just shows up for work and does as little as possible. And then goes home with less money, more importantly, less time and energy. This is your LIFE! And we only get one chance to live (That we know of. Buddhist monks believe that we live MANY lives. ☺).

A leader understands that his/her job is to serve his number one client, and that is the people who work "with" them. A boss keeps it very clear that he/she doesn't have the ability to encourage, motivate, stimulate, and activate threw encouragement of

example. It's to exhausting. Instead, they demand or delegate the demands several levels below. The people in the middle will agree with the boss, say whatever they can to keep him/her satisfied, and then decide how that demand will be instigated based of the neglect "they" have already done months previous. But use the people below as the escape goat, and they become politicians in getting as little done as possible. But keep feeding the ego of the boss. YES… This has been going on for years with companies. But not today…. Several companies are now expanding without the primitive boss dictatorship. No managers, no supervisors. Companies worth billions today. ESOP companies should be the same… Shouldn't they?

A leader understands that he/she needs to be the BEST listener on every level. Those working in the trenches with the tools of their job. Whether the tools work or not. Those in front of the MOST important person, the customer, who naturally expresses the mantra of the business. The energy (Or lack of it) passed down from the top. The employee

is the customer of the upper level positions. Do you understand this? Your job is to help them stay involved in the business because people get excited about being a PART of a business. Image what would happen if everyone looked at the business like it was their business. (Isn't Recology an ESOP business in the first place? What the hell is going on. Has it been hijacked?)

A boss walks around with an obvious ego, even when they're trying not to look like they do. People are more perceptive today. It comes from years and years, generations and generations of he who has the bigger stick, has more. It's primitive and ignorant. Today it's time to evolve from the early 1900's mentality, the industrial revolution is dead. Being an ESOP company is a great step in the right direction. And I'm not sensing too many people carrying around the big stick ego in Recology... Which is good. I do sense something even more detrimental.... The land of nothingness. An empty space, or a vacuum, of upper management talking and talking. But once again, nothing is done but

meetings and talking. Coffee, lunch, I-Phones, and Emails. It took the HR department 6 months to hire someone for the position I didn't get. I don't care what you say…. That is a disgrace to any human. Doesn't this technology we have today speed things up? Apparently not.

I wasn't hired after 11 months working as a temp for Recology. I wanted to continue working here for a personal goal I have in the arts. It wasn't about the low paying job for me, I structured my life accordingly. I really don't know why they didn't hire me. Maybe it was my background check with something that showed up (As it did when I went to rent a house two years ago. It wasn't my report and was cleared up with the rental house because they told me something showed up. I wasn't given a reason why they didn't hire me with Recology). Maybe because I have been out spoken and written three letters to the CEO about what I see as being neglected and could run more efficiently (I can understand what a pain in the ass that could be ☺). Several people have their hands tide and didn't

want to shake the boat. I was a temp... I'll say it, why not. I was just trying to be apart of Recology. I truly cared and wanted to "just be me" because I happen to believe in me. I work hard! I get into it! I care about business. And not once did we have any drama between fellow workers here at this location. We bounced ideas and …. Worked. It was a pleasure.

This isn't just about Recology. I've ridden this rodeo with a couple of other major companies. And I'm proud (But have paid dearly for it) that I see very clearly the differences between a boss and a leader. A dictatorship and a enterprise. Opportunity versus enslavement. Common sense versus book smart. (No, they don't go together. Just look around) BALANCE….. In every aspect of life.

I worked for a large company as a rout builder. (Schwan's Food) My job was to prospect in normal routs and create more customers. I knocked doors with the smaller truck and invited people to our services. I was creating 20 to 50 new customers a day. At the end of the month I was expecting a rather

large check. I worked 60 to 70 hours a week. My check was $1,600.00 and I asked the depot manager if they made a mistake. We looked at my sales records and he pointed out what happened.

In my employment handbook (Which was about 500,000 pages long) it "clearly stated" that any commissions over 11 new customers a day isn't required, and isn't commissioned. In other words, some genius in the strategic department created this profound math mobile. Anymore than 11 a day wasn't good for business. They were doing $25 Million a day worldwide. Anything more was overkill. Well thanks for the memo. So I would go out and do my job until I had 11., usually by noon, and turn my truck in and go home. This didn't go over well so I quit and Yes... Wrote the CEO.

Did they change that rule? YES.... I ran across a Schwan's guy 3 years later and he said they changed it to unlimited. But ran across another Schwan's guy last year, and they changed it back. So more business isn't good. Hummmm...... Weird. It doesn't add up

other than crossing the line with something else. Some turf thing. Or some political thing. The Big Bosses of the world. Who should all be fired so we can get back to leaders.

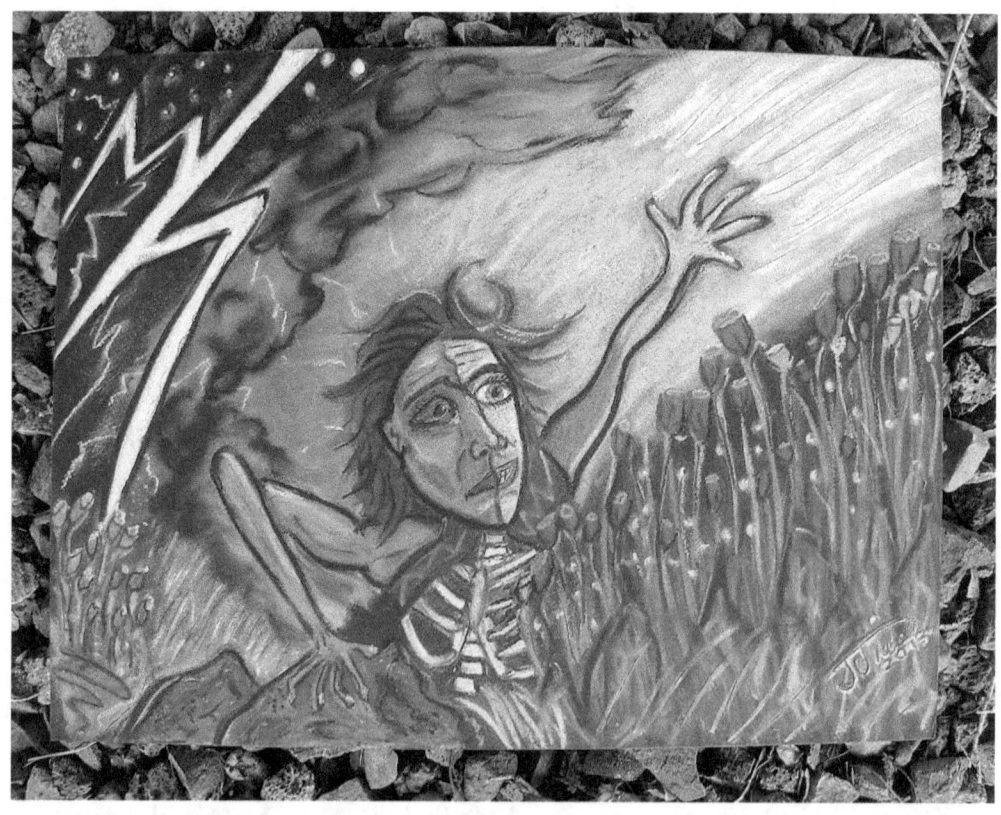

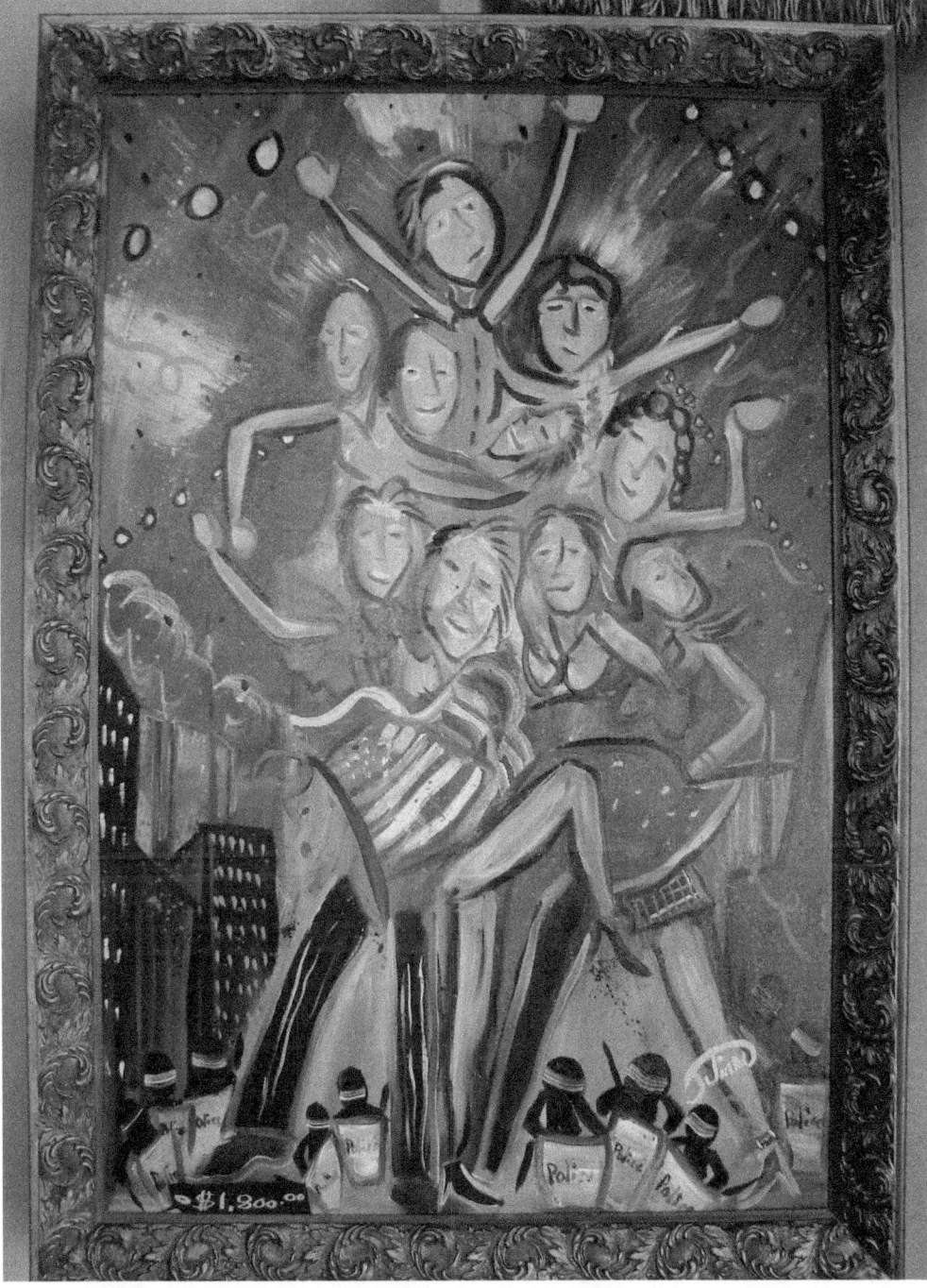

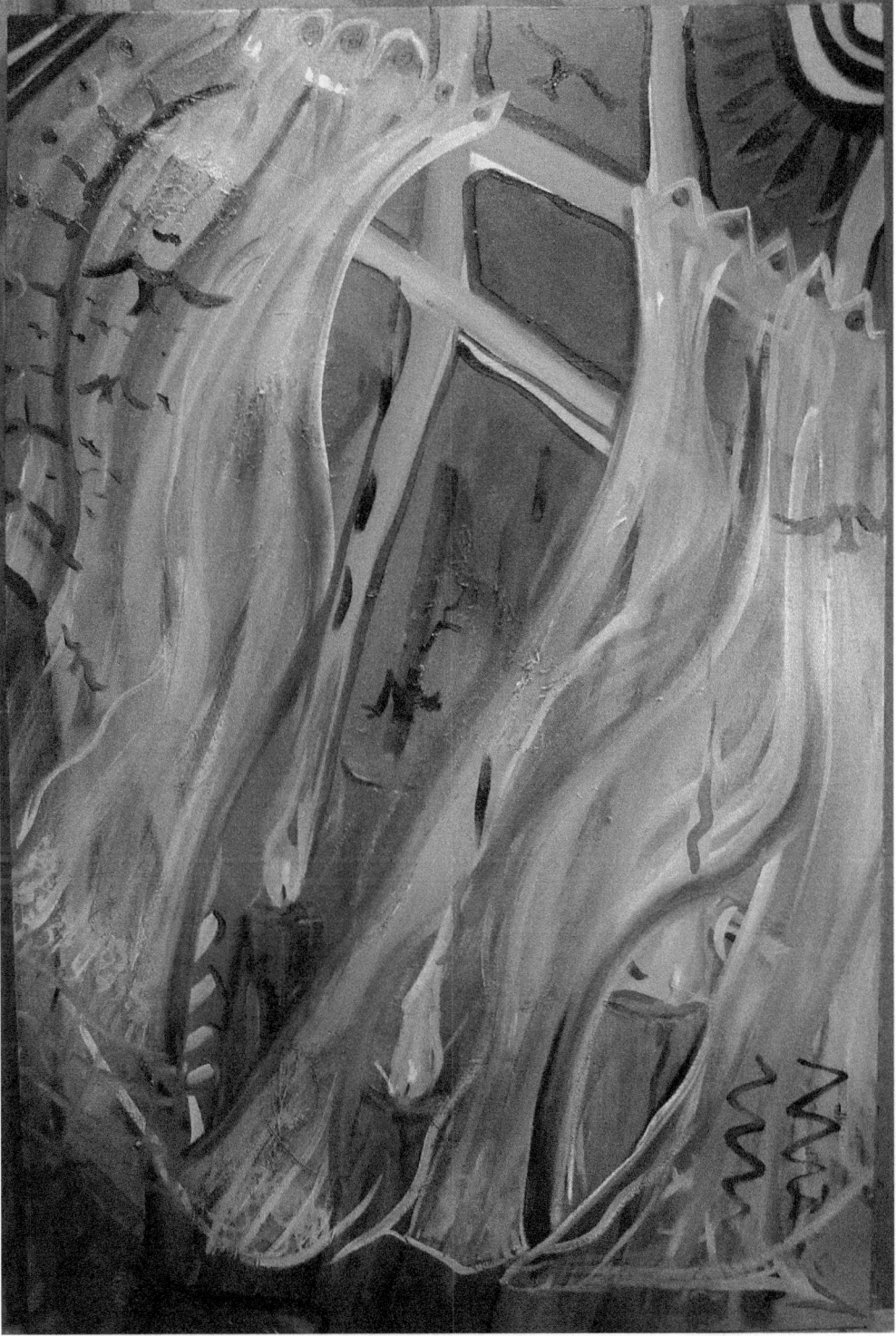

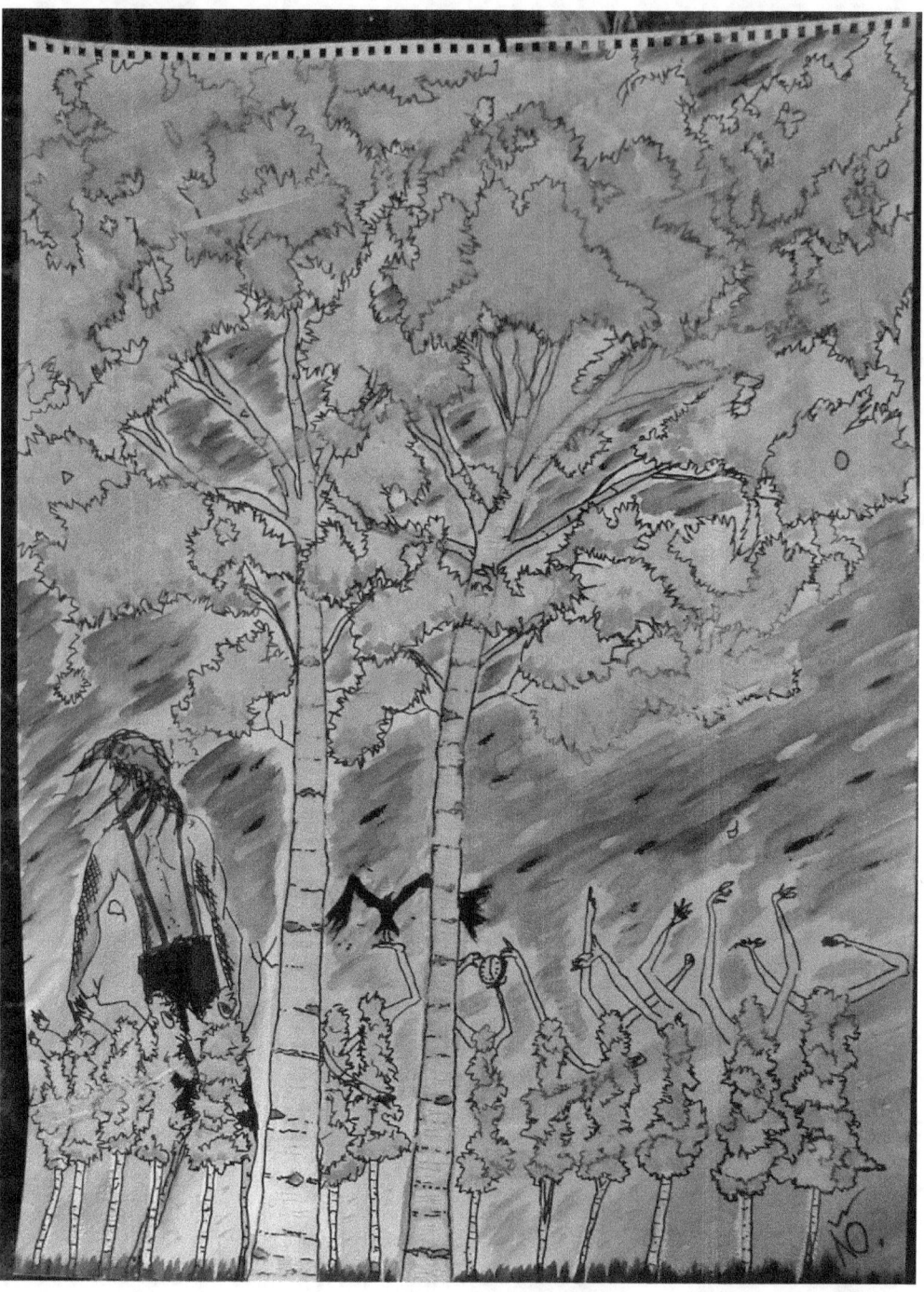

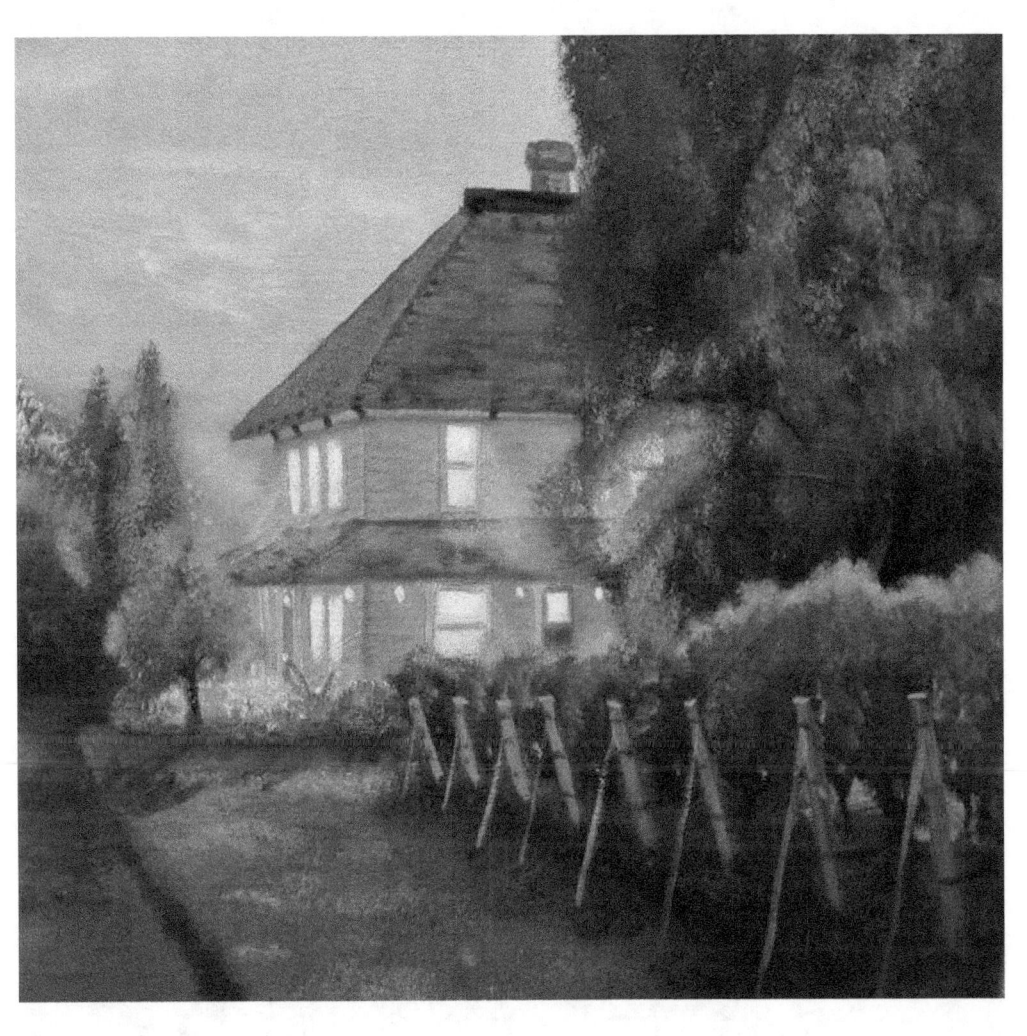

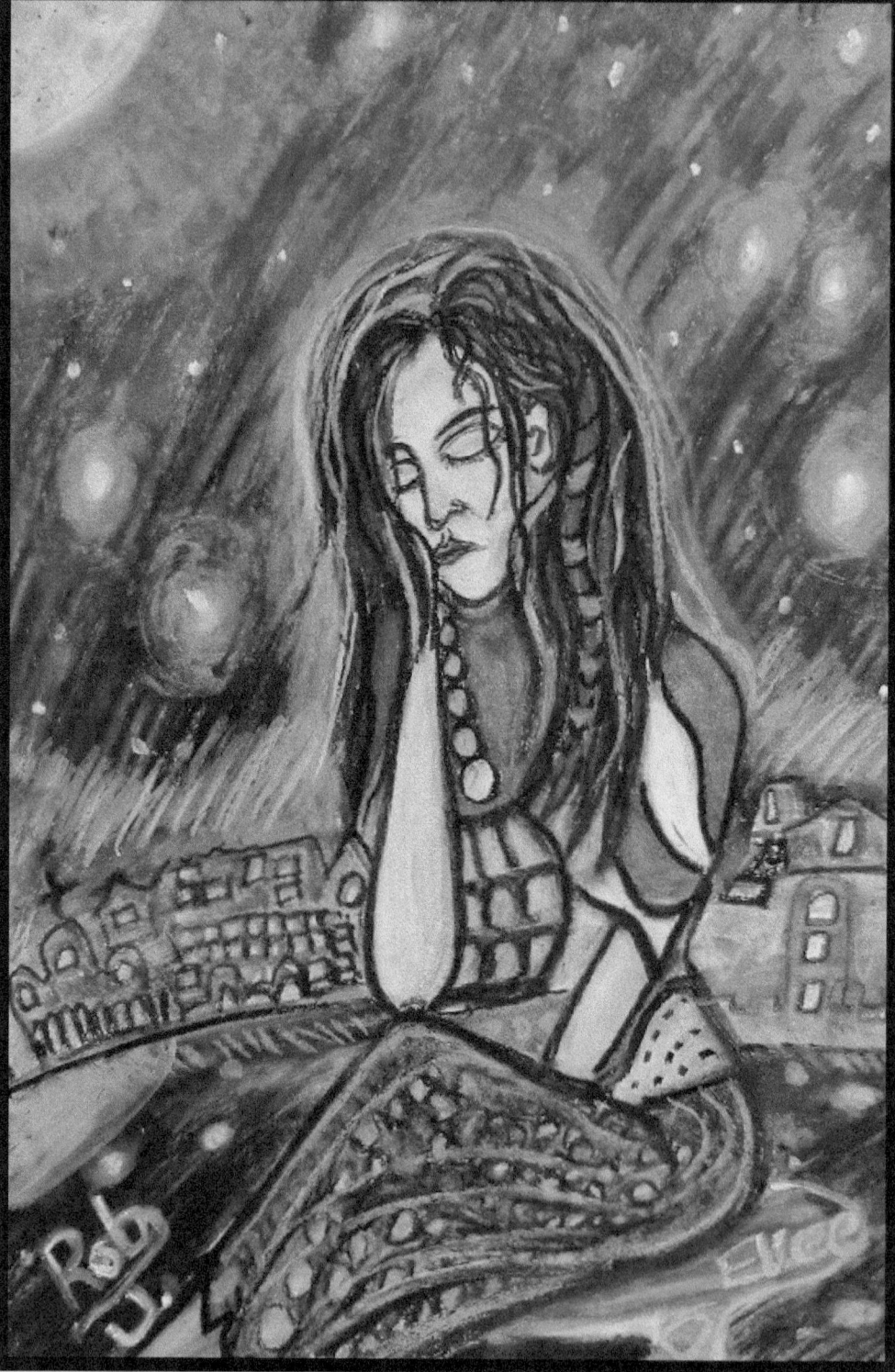

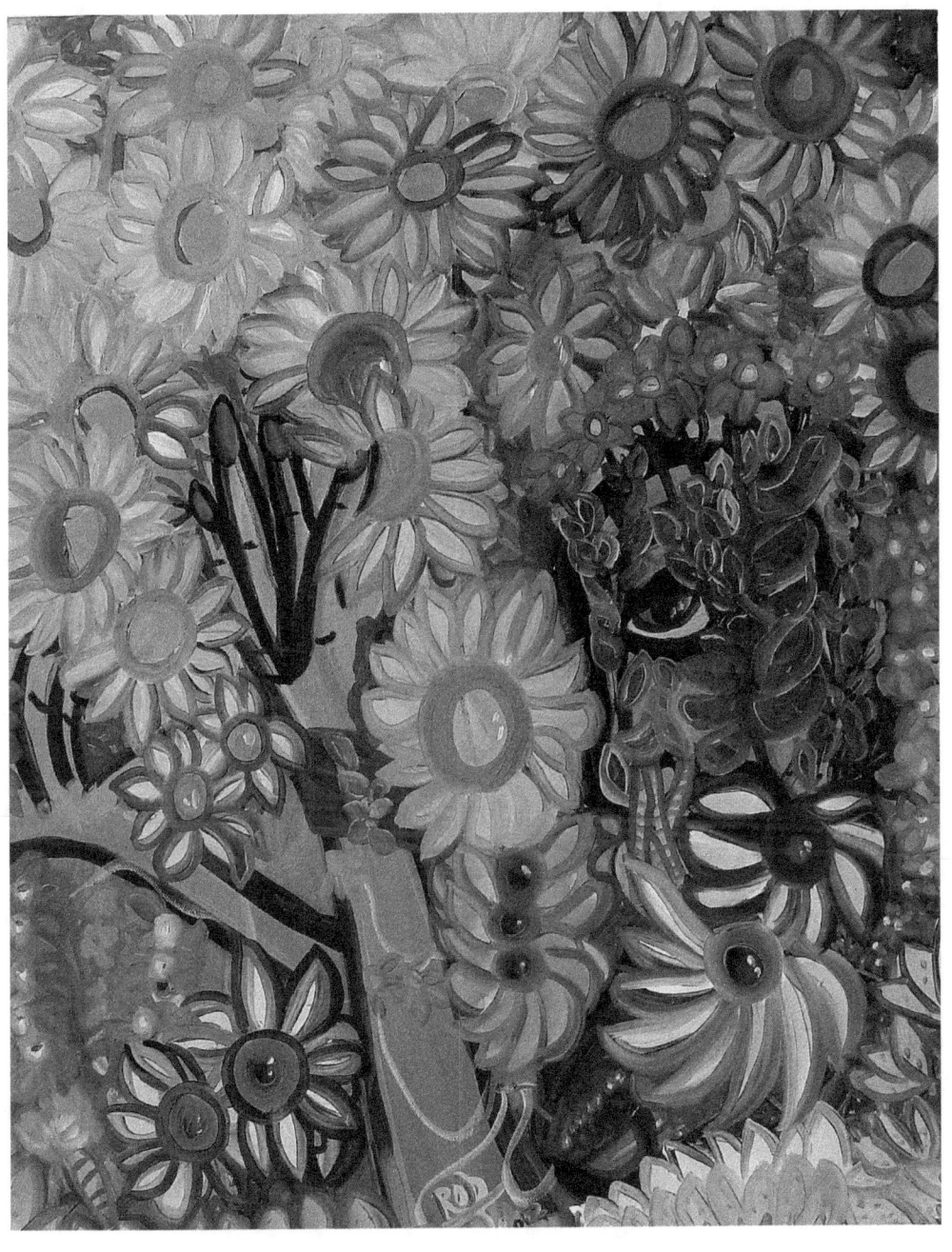

None of this had to make any sense. It is CREATIVITY. No order.... Just breathed in and out.

I hope you enjoyed this short experience.

Create!!!!!

Author

Rob Juliano ~ Is a born artist, philosopher, scientist and story teller. He avoided the arts most of his life, struggling to conform to the standard traditions which did not allow his free-flowing nature to expand. Always 'different', yet learning how to comply, he played the game masterfully until 2007. After a conscious choice to live in the mountains, meditating 4 to 6 hours a day *(eat me bears, eat me cougars, I didn't care!)* ~ then the eyes finally opened...and truth was revealed.

There is a message within every *breath~stroke* that is felt. Every word that is written, by opening up to universal awareness. Nurturing our inner child, once our minds are cleared, rather than living in the static of old, stuffy, reactive conditioning, allows us to truly be free. Within the movement of a new, yet ancient understanding called FAITH, these paintings and writings have a life of their own ~ Nature's Flow. As we evolve and pay attention to the abstract potentiality, it is amazing how a tangible creation brings one to the 'here and now', in trusting their heart.

Looking closely and deeply into each painting, each writing, allows one to feel something organically. This art becomes more profound with time, as wisdom is born. Trusting our intuitive hearts opens us up to Heaven's permission for us to play! The Earth is your reflection...OUR reflection. She is saying today...FEEL from love. Being okay with our uniqueness, returns us to our truest nature. In the NOW, you get to be the authentic yoU!

www.ingramcontent.com/pod-product-compliance
Lightning Source LLC
Chambersburg PA
CBHW071808170526
45167CB00003B/1222